Introduction to

Object ID

Guidelines for Making
Records that Describe Art,
Antiques, and Antiquities

Introduction to

Object ID
Guidelines for Making Records that Describe
Art, Antiques, and Antiquities

Robin Thornes
with Peter Dorrell and Henry Lie

Getty Information Institute

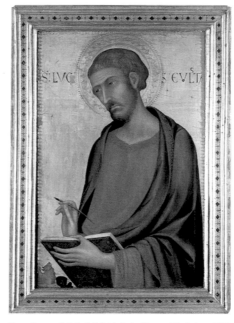

Cover image: Detail of *Saint Luke* by Simone Martini, ca.1330. Tempera on panel, 67.5 × 48.3 cm. From the collection of the J. Paul Getty Museum, Los Angeles, California.

Project Associate: Cynthia Scott
Editor: Anita Keys
Design: Hespenheide Design
Printing: Typecraft, Inc.
Figure 1: James Robie Design
Photographs for Part II: Stuart J. A.
 Laidlaw, Institute of Archaeology,
 London, except figure 28a, Peter
 Dorrell, Institute of Archaeology,
 London

Library of Congress Cataloging-in-
Publication Data
Thornes, Robin.
Introduction to Object ID : guide-
 lines for making records that
 describe art, antiques, and
antiquities / Robin Thornes with
Peter Dorrell and Henry Lie.
 p. cm.
 Includes bibliographical
 references.
 ISBN 0-89236-572-2 (pbk. :
 alk. paper)
 1. Art—Documentation—Stan-
dards. 2. Antiques—Documenta-
tion—Standards. 3. Antiquities—
Documentation—Standards.
I. Dorrell, Peter G. II. Lie, Henry.
III. Title. IV. Title: Object ID.
N3998.T457 1999
707'.5'3—dc21 99-27209
 CIP

Contents

Foreword

The Object ID project began with two premises: One, a stolen object cannot be returned to its rightful owner unless it has been adequately documented; and two, in the case of theft, the information about the object should be able to travel rapidly across the world and be circulated among a number of organizations. Both premises require agreement on what information constitutes an adequate record for identifying an object. Such an agreement must be based on a broad consensus among those organizations with a role to play in the protection of the movable cultural heritage at international, national, and local levels, and in both the public and private sectors.

The project established that such a consensus does exist, and succeeded in gaining agreement on a documentation standard that reflects this consensus. The contents of Object ID were identified by research, interviews, consultative roundtable meetings, and international questionnaire surveys. The result is a documentation standard that is deceptively simple: nine categories of information, plus a short description and an image that can identify an object. However, that simplicity represents the distillation of four years' discussion with police and customs agencies, cultural heritage organizations, the art trade, and the insurance industry. It reflects current practice among the organizations in these communities, and meets the essential requirement of being easy to implement and use by specialists and non-specialists alike.

The success of the project is due in large measure to the willingness of a large number of organizations (over one thousand worldwide) to participate in the consultation process. The J. Paul Getty Trust would like to thank all those who assisted in the development of Object ID and, in particular, its partners in the project: the United Nations Educational, Scientific and Cultural Organization (UNESCO), the Council of Europe, the International Council of Museums (ICOM), and the United States Information Agency.

The Object ID project's contribution to combating art theft resides in establishing a minimum standard for describing art, antiques, and antiquities by encouraging the making of descriptions of objects in both private and public ownership, and by bringing together organizations that can encourage its implementation, as well as those that will play a part in developing networks along which this information can circulate. Object ID is just one small piece of paper, but it represents something very big: the establishment of common ground between organizations around the world—common ground that can help lay the foundations for effective collaboration to protect our cultural heritage.

The Project Team

For the Getty, Eleanor Fink, former Director of the Getty Information Institute, identified the need for the Object ID standard, initiated the project, and supported the development throughout its evolution. Consultant Robin Thornes coordinated the project, acted as its chief strategist, and produced its publications. First Joseph Busch and then Marilyn Schmitt directed the project for the Institute. Cynthia Scott managed the many activities of the project and coordinated its publications and North American operations. Jane Ashworth acted as the project's research assistant. Nancy Bryan edited the project's publications. Margaret Mac Lean and Suzanne Deal Booth coordinated the contribution of the Conservation Specialists Working Group. Kathleen McDonnell oversaw the project's implementation phase.

Acknowledgments

Thanks are extended to all those who contributed to this publication. In particular, the J. Paul Getty Trust would like to pay tribute to Peter Dorrell, who died in May 1996 shortly after completing the second draft of Part II of this publication. Lecturer in Archaeological Photography at the Institute of Archaeology, London (ret.) and Associate Director of the British Museum excavations at Tell-es-Sa'idiyeh in Jordan, his bibliography includes *Photography in Archaeology and Conservation* (Cambridge University Press, 1989). One of the best-loved figures in the fields of Near Eastern archaeology and archaeological photography, he impressed all who knew him with his professionalism, energy, and sense of humor. This book is dedicated to his memory.

Peter Dorrell

Robin Thornes completed the final drafts of Part II and coordinated its incorporation into the publication.

Thanks are also extended to Henry Lie, Director of the Strauss Center for Conservation and Conservator of Objects and Sculpture at the Harvard University Art Museums, for writing the section on Distinguishing Features. A Fellow of the American Institute for Conservation and Associate of the International Institute for Conservation, he was a member of the Conservation Specialists Working Group established by the Getty Conservation and Information Institutes to advise the Object ID project. He has written a number of articles on aspects of the conservation of artworks and is an expert on the maintenance of outdoor sculpture.

The following individuals are thanked for commenting on the text of this publication: Murtha Baca (Getty Research Institute for the History of Art and the Humanities); John Bold (Royal Commission on the Historical Monuments of England); Nancy Bryan (formerly of the Getty Information Institute); Richard Ellis (formerly of the Metropolitan Police Service, London); Alice Grant (Science Museum, London); Robin Jones (Southampton Institute, U.K.); Stuart Laidlaw (Institute of Archaeology, London); Marilyn Schmitt (formerly of the Getty Information Institute); Cynthia Scott (Getty Information Institute); Nicholas Somers (past chairman of the Fine Arts and Chattels Committee of the Incorporated Society of Valuers and Auctioneers, U.K.); James Stevenson (Victoria and Albert Museum, London); and Victor Wiener (Appraisers Association of America).

The J. Paul Getty Trust would also like to thank the following organizations for contributing to the development of Object ID: American Association of Museums; American Society of Appraisers; Appraisers Association of America; Art Dealers Association of America; British Antique Dealers Association; Canadian Heritage Information Network; Confédération Internationale des Négociants en Art (CINOA); Council of Europe; Council for the Prevention of Art Theft (U.K.); Department of Culture, Media and Sport (U.K.); Federal Bureau of Investigation; Heritage Council (Ireland); Incorporated Society of Valuers and Auctioneers (U.K.); International Art Loss Register; International Association of Dealers in Ancient Art; International Foundation for Art Research; International Council of Museums particularly the documentation committee (CIDOC); INTERPOL Secretariat General; INTERPOL-U.S. National Central Bureau; London and Provincial Antique Dealers Association; Metropolitan Police Service (U.K.); Ministry of Culture of the Czech Republic; Ministry of Education, Culture, and Science (The Netherlands); Museum Documentation Association (U.K.); Nederlande Organisatie van

Makelaars Veilinghouders en Beëdigde Taxateurs in Roerende Goederen en Machinerieëen; Organization for Security and Cooperation in Europe; Private Art Dealers Association (U.S.); Private Art Dealers Association of Canada; Royal Commission on the Historical Monuments of England; Royal Institution of Chartered Surveyors (U.K.); Smithsonian Institution; Thesaurus Group; UNESCO; Union Français des Experts Specialisés en Antiquités et Objets d'Art; U.S. Information Agency; U.S. National Parks Service; and World Customs Organization.

Introduction

What Is Object ID?

Object ID is an international standard for the minimum information needed to identify art, antiques, and antiquities, developed through the collaboration of the museum community, police and customs agencies, the art trade, the insurance industry, and appraisers of art and antiques. The standard is best defined in terms of its several uses:

- as a checklist of the information required to identify stolen or missing objects;
- as a documentation standard that establishes the minimum level of information needed to identify an object;
- as a key building block in the development of information networks that will allow organizations around the world to exchange descriptions of objects rapidly;
- as a key component in any training program that teaches the documentation of art, antiques, and antiquities.

Why Object ID Is Needed

The illicit trade in art, antiques, and other cultural objects now constitutes one of the most prevalent categories of international crime. Law-enforcement agencies, in particular, have long recognized that documentation is crucial to the protection of cultural objects, for law-enforcement officials can rarely recover and return objects that have not been photographed and adequately described. Unfortunately, very few objects have been documented to a level that can materially assist in their recovery in the event of theft. Even for objects that have been so documented, the information collected is extremely variable. It is important, therefore, that efforts be made to increase public awareness of the need to make adequate, standardized descriptions of objects. More and better documentation will not only

assist crime detection and the recovery of stolen objects, but also have considerable value as a crime-prevention strategy.

It is one thing to encourage the compilation of descriptions of objects as a security measure, but quite another to develop effective means of circulating this documentation to organizations that can assist in the recovery of the objects if they are stolen. Ideally, the information that can identify a stolen or illegally exported object should be able to travel at least as fast as the object itself. This will mean that the information may have to cross international borders and circulate among a number of organizations. The development of electronic networks makes this effort technically possible. However, digital information and computer networks to transmit the information will solve only part of the problem. Also necessary are the standards that will make it possible to exchange information in a form that is intelligible to both systems and people. Object ID meets the second of these requirements by providing a documentation standard for the information needed to identify objects.

The Making of Object ID

In 1993, discussions between the Getty Art History Information Program (renamed the Getty Information Institute in 1996) and leading national and international umbrella agencies and government bodies established that consensus had been reached on the need to collectively address issues relating to documentation practices and the implementation of international standards. In July of that year, the Getty institute convened a meeting in Paris to discuss the possibility of developing an international collaborative project to define documentation standards for identifying cultural objects. The meeting was attended by representatives of the Conference for Security and Co-operation in Europe (now the Organisation for Security and Co-operation in Europe), the Council of Europe, the International Council of Museums, INTERPOL, UNESCO, and the U.S. Information Agency. The participants agreed on the need for such an initiative and recommended that it focus on developing a standard for the information needed to identify objects, and on mechanisms for implementing the standard.

From the outset, the project recognized the need to work collaboratively with organizations in six key communities:

- cultural heritage organizations (including museums, national inventories, and archaeological organizations)
- law-enforcement agencies
- customs agencies
- the art trade

- appraisers
- the insurance industry

The first step toward establishing consensus on the proposed documentation standard was to identify and compare the information requirements of each of these communities. These requirements were identified by a combination of background research, interviews, and, most importantly, major international questionnaire surveys. The Getty Art History Information Program carried out the first of these surveys between July and December 1994 with the endorsement of the Council of Europe, ICOM, and UNESCO. Organizations in forty-three countries responded to the survey, including major museums and galleries, heritage documentation centers, INTERPOL, and national law-enforcement agencies. The survey took full account of existing standards and standards-making initiatives in the museum world, including those of the International Council of Museums, the Museum Documentation Association (U.K.), and the Canadian Heritage Information Network.

The results of this preliminary survey—published in July 1995 in *Protecting Cultural Objects through International Documentation Standards: A Preliminary Survey*[1]—demonstrated that broad consensus did indeed exist on many of the categories of information. These became candidates for inclusion in the proposed standard. Encouraged by these findings, the project went on to survey the information needs of the other key communities: dealers in art, antiques, and antiquities, appraisers of personal property, art insurance specialists, and customs agencies. More than one thousand responses from organizations in eighty-four countries and dependencies made this survey the largest of its kind ever conducted (see figure 1).

The findings of the questionnaire surveys were used to brief a series of roundtable meetings of experts drawn from the communities concerned. The series began with the first meeting of an international Conservation Specialists Working Group, organized jointly by the Getty Art History Information Program and the Getty Conservation Institute, in Washington, D.C., in August 1994. A key recommendation of this meeting was that the standard should include a category called **Distinguishing Features**, to record information about an object's physical characteristics, such as damage, repairs, or manufacturing defects, that could help identify it uniquely.[2] This recommendation was later strongly endorsed by the other communities consulted.

A meeting of museum documentation experts, held in Edinburgh in November 1995, followed the Washington roundtable. Its recommendations have been little changed by the findings of subsequent surveys and the recommendations of later meetings. An important

Algeria	El Salvador	Kuwait	Romania
Argentina	Estonia	Latvia	Russia
Australia	Finland	Lithuania	Slovakia
Austria	France	Macau	Slovenia
Bangladesh	Gabon	Madagascar	South Africa
Barbados	Germany	Malaysia	Spain
Belgium	Ghana	Malawi	Sudan
Belize	Greece	Mauritius	Swaziland
Bermuda	Guyana	Mexico	Sweden
Botswana	Hong Kong	Mongolia	Switzerland
Brunei	Hungary	Namibia	Syria
Canada	Iceland	The Netherlands	Thailand
Chile	India	New Zealand	Ukraine
Colombia	Indonesia	Nicaragua	Union of Myanmar
Congo	Ireland	Nigeria	United Kingdom
Croatia	Israel	Norway	United States of
Cuba	Italy	Pakistan	America
Cyprus	Jamaica	Peru	Venezuela
Czech Republic	Japan	The Philippines	Vietnam
Denmark	Jordan	Poland	Zambia
Ecuador	Kenya	Portugal	Zimbabwe
Egypt			

Figure 1 **Countries responding to the international questionnaire surveys.**

milestone for the project, this gathering demonstrated the possibility of establishing consensus among professionals within the key communities addressed by the project.

A third meeting assembled art-insurance specialists at Lloyd's of London in March 1996. The fourth meeting—held at the Winterthur Museum in Delaware in October of the same year—brought together organizations representing dealers and appraisers of art, antiques, and antiquities. The final meeting, held in November 1996 in Prague in partnership with UNESCO and the Czech Ministry of Culture, convened representatives of law-enforcement agencies and commercial organizations that operate computerized art theft databases.

The surveys and roundtable meetings established that strong agreement existed on the categories of information that should constitute the standard (see *Protecting Cultural Objects in the Global Information Society: The Making of Object ID*.[3] The result, Object ID, offers a standard simple enough to be used by non-specialists, and capable of being implemented in traditional, non-computerized inventories and catalogues as well as sophisticated automated retrieval systems.

International organizations, including UNESCO,[4] the Council of Europe,[5] INTERPOL, and the International Council of Museums

(ICOM),[6] have welcomed and recognized the importance of Object ID. A number of major law-enforcement agencies now use it, including the U.S. Federal Bureau of Investigation (FBI) and Scotland Yard in the United Kingdom. Organizations representing appraisers of personal property on both sides of the Atlantic have endorsed it, and art insurers and bodies representing the art trade are promoting its use.

This publication is divided into two parts. Part I describes the information categories included in the Object ID standard, plus some additional categories that were not unanimously selected for inclusion but nonetheless may prove useful to some communities. Part II offers practical advice on how to photograph objects—an important element in the documentation process.

Figure 2 **The findings of the project's initial questionnaire survey were published in 1995 in** *Protecting Cultural Objects through International Documentation Standards: A Preliminary Survey*. **Around twelve thousand copies of the report have been circulated worldwide.** *Protecting Cultural Objects in the Global Information Society*—**a short video publicizing the work of the project—was released in 1996. The project's final report,** *Protecting Cultural Objects in the Global Information Society: The Making of Object ID*, **was published to coincide with the launch of Object ID in May 1997.**

Notes

1. R. Thornes. *Protecting Cultural Objects through International Documentation Standards: A Preliminary Survey.* Santa Monica: Getty Art History Information Program, 1995.

2. The findings of the questionnaire surveys carried out since then have strongly endorsed this recommendation. Ninety-eight percent of customs agents, 97 percent of cultural heritage organizations (supplementary survey), 96 percent of appraisers, 95 percent of law-enforcement agencies (supplementary survey), and 88 percent of the art trade have approved it.

3. R. Thornes. *Protecting Cultural Objects in the Global Information Society: The Making of Object ID.* Santa Monica: Getty Information Institute, 1997.

4. The Object ID checklist has been reproduced in the 1997 UNESCO publication *Preventing the Illicit Traffic in Cultural Property: A Resource Handbook for the Implementation of the 1970 UNESCO Convention* by E. Clément and P. Askerud. The tenth meeting of UNESCO's Intergovernmental Committee for Promoting the Return of Cultural Property (Paris, 25–28 January 1999) endorsed Object ID "as the international standard for recording minimal data on movable cultural property" and invited the Director General "to bring this recommendation on Object ID to the attention of the General Conference and to recommend that all UNESCO Member States adopt Object ID and use it, to the fullest extent possible, for identification of stolen or illegally exported cultural property and international exchange of information on such property" (Resolution 5).

5. Object ID is included in *Documenting the Cultural Heritage,* a publication produced as the result of a collaboration among the Getty Information Institute, the Council of Europe, and the European Foundation for Heritage Skills.

6. The documentation committee of the International Council of Museums (CIDOC) actively supported the Object ID project and, at its request, the ICOM Executive Committee adopted the resolution: "A museum should be able to generate from its collection information system such data (preferably according to the Object ID standard) that can identify an object in case of theft or looting."

Part I Describing Art and Antiques Using Object ID

Overview

This part of the publication offers guidelines for using Object ID's nine information categories—**Type of Object**, **Materials & Techniques**, **Measurements**, **Inscriptions & Markings**, **Distinguishing Features**, **Title**, **Subject**, **Date or Period**, and **Maker**, as well as suggestions for the preparation of written descriptions of objects. It also includes brief discussions of five additional categories of information not selected for inclusion in Object ID because there was no clear consensus on their importance. These categories are: **Inventory Number**, **Related Written Material**, **Place of Origin/Discovery**, **Cross Reference to Related Objects**, and **Date Documented**. All were regarded as being important by a majority of respondents in at least four of the six communities surveyed.

Records that describe art, antiques, and antiquities serve a variety of purposes, including the protection, conservation, management, recovery, valuation, and sale of objects. Different types of organizations inevitably have different information needs. For example, police hold information concerning the circumstances of an object's theft, museums need information on the location of an object and proof of ownership, the art trade is interested in the provenance of an object, while appraisers record the value of an object together with the basis of the valuation. However, although the information needs of these organizations vary, they all need documentation that identifies individual objects. Broad consensus across the various communities on the categories of information essential to identify objects was the essential precondition to a successful outcome to the Object ID project.

The differences between the communities in their approach to documentation do not end with the categories of information included in records. Differences also exist in the importance accorded to particular categories and in the ways in which the information is recorded. Police officers, for example, are not "art trained" and tend to place a strong emphasis on photographs and "non-expert" information that can be

gained by a physical inspection of the object, for example, **Type of Object**, **Materials & Techniques**, **Measurements**, **Inscriptions & Markings**, and **Distinguishing Features**. While subject is important, they tend to describe it in terms of what is depicted rather than its esoteric iconographic meaning, such as *man with bull's head* rather than *Minotaur* (see **Subject**). The art trade, on the other hand, describes the object with language designed to demonstrate a knowledge of the object and to appeal to a potential buyer, while cultural heritage organizations are interested in describing the object in terms of its historical significance and cultural meaning.

These differences in approach often mean that the various communities record the same basic information, but in ways that are not mutually acceptable. For example, police find scholarly descriptions unhelpful to non-expert officers, while museums and the art trade do not wish to use what they regard as overly simple terms. This publication seeks to bridge this gap by providing advice derived from a study of the needs and current practices of all the communities mentioned above. It offers suggestions on ways of describing objects to make them more identifiable by both experts and non-experts alike, and seeks to strike a balance between technical and scholarly ways of describing objects and more widely understandable non-specialist language. However, the advice given will not conform in all cases to the current practices of a particular community. It is left to individual organizations to determine to what extent they feel able to follow the guidance provided.

The Object ID checklist is purposefully short and simple. Indeed, it represents a far smaller sampling than the documentation standards developed by cultural heritage organizations. Even so, it will not always be feasible or even desirable for organizations or individuals to provide all the Object ID categories of information for every object in their collections. The Object ID checklist indicates the categories of information that can be used to help identify an object, but the discretion of the individual or organization must determine which categories to record in a particular case and at what level of detail.

Object ID is not an alternative to existing standards. Rather, it is a core standard created for a very specific purpose—that of describing cultural objects to identify them. As such, it can "nest" within existing retrieval systems, information standards, and codes of practice.

Since Object ID is intended to be used by a number of communities and by specialists and non-specialists alike, it identifies broad concepts rather than specific fields and uses simple, non-technical language. This publication suggests ways of recording information in order to identify objects, whether in the form of handwritten descriptions or computerized records—rather than to implement the standard in automated

systems. When implemented in a computerized system, Object ID categories may equate to a single field, or be broken into several fields. For example, the Object ID category **Materials & Techniques** comprises two fields in some systems, and the categories **Measurements** and **Date or Period** may break into three or more fields. Nevertheless, the discussions of the Object ID categories in this publication are intended to be of value to those developing computerized databases, as well as to those who create records of art, antiques, and antiquities.

Categories of Information

Type of Object

What type of object is it (e.g., painting, sculpture, clock, mask)?
The first question most people ask themselves when confronted with an object is "What is it?" It is not always possible to provide an answer in anything but the broadest terms, for example, *clock*. In most cases only an expert will be able to identify the object exactly, for example, *quarter-repeating spring carriage clock*.[1] It is important to attempt an answer, however broad, because this category acts as the primary means of classifying objects, and is crucial for locating records of objects in both manual and automated retrieval systems.

Type of Object is recorded either in the form of a single term (e.g., *spear*) or as a short descriptive phrase that combines a number of pieces of information, such as the object's form, function, materials and techniques of construction, color, mechanism, subject, maker, place of origin or discovery, and period.

> **Examples:**
> warrior ear ornament
> Meissen vase with chinoiserie decoration
> gray limestone head of a Buddha
> English eighteenth-century diamond spray brooch
> red lacquered ormolu musical automaton clock

What if a particular type of object is known by a number of widely used names? For example, *long-case clock*, *tall-case clock*, and *grandfather clock* are different names for the same object. More than one term for the same object causes problems when it comes to retrieving information. If an object is documented using one term, and searched for using another, it will not be found. For this reason, some organizations select one term to be the "preferred term"—the term used by the organization to describe a particular type of object—and make other terms synonyms. For

bureau cabinet

architect's cabinet
bureau cabinet
cabinet-on-stand
china cabinet
corner cabinet
display cabinet
gun cabinet
hanging cabinet
music cabinet
side cabinet

Figure 3 **Some systems provide users with a list of approved terms from which to choose when entering and retrieving information.**

example, the preferred term might be *short-case clock* and the synonym *grandmother clock*. This process may be taken further by providing a list of approved terms from which to choose when entering and retrieving information (see figure 3). This "pick-list" approach makes the information more retrievable and is useful in multilingual databases by creating links between the names of an object in different languages. On the other hand, it tends to restrict users by offering too few choices, resulting in the need for the options *other* or *miscellaneous* for terms not covered by the list.

Many organizations categorize their objects at two levels, placing them in broad categories (e.g., *arms and armour*) as well as specific types (e.g., *breast-plate*). Some go further by employing on-line, hierarchically structured thesauri to enable information to be entered and retrieved at a number of levels.

Example:
Level 1 *furniture*
Level 2 *chair*
Level 3 *windsor chair*
Level 4 *fan-back windsor chair (U.S.)*

Perhaps the best known of these thesauri is the *Art & Architecture Thesaurus* (AAT) (www.gii.getty.edu/vocabularies/aat), a controlled vocabulary that provides terms for documentation of the cultural heritage. The AAT aids retrieval of information in computerized databases by providing paths composed of synonyms, broader and narrower terms, and related concepts. The tool enables users to refine, expand, and enhance searches and achieve more comprehensive and precise results (see figure 4).

A collection of related objects such as a *baptismal set* requires a choice as to whether to describe individual component parts or the set as a whole. For example, a *tea and coffee service* comprises a number of objects—i.e., *teapot, coffee cups, tea cups, saucers, plates, cream jug, sugar bowl, and slop bowl*—that can be described either as a whole or as a number of individual related objects. The service can be documented as a whole by entering the collective name under **Type of Object** and providing a description of the individual objects using the category **Description**.

Example:
Type of Object: tea and coffee service
Description: A Spode tea and coffee service painted in red, blue-green, and gold with birds, flowers, and foliage in the Oriental style, comprising: 7 in. teapot and cover, 4.5 in. cream jug, five tea cups, six saucers, 5 in. sugar bowl and cover, 5 in. slop bowl, and six coffee cups.

Figure 4 **The *Art & Architecture Thesaurus* (AAT), a coordinated vocabulary, provides terms for documenting the cultural heritage. This figure shows just some of the terms retrieved when the AAT is searched using the term *clock*.**

Bear in mind that some objects incorporate or comprise other objects of a different type, made of different materials and techniques, or by a different maker at a different date.

Example:
Gold intaglio bracelet set with thirteen cornelian and hardstone intaglios, mostly Roman first to third century A.D., the intaglios mounted in gold ca. 1820.

Materials & Techniques

What materials is the object made of (e.g., brass, wood, oil on canvas)? How was it made (e.g., carved, cast, etched)?
This category records the materials and techniques used in the creation and decoration, as well as in any subsequent repairs to or adaptations of the object. Descriptions of objects often combine these two types of information (e.g., *pen and black ink with gray wash on paper*), making it difficult for non-experts to distinguish between a material and a technique. To obviate that confusion, Object ID brings the two together in the single category—**Materials & Techniques**.

Non-experts may know that an object is made of *wood*, maybe even that it is made of more than one type of wood, but not that it is of

rosewood cross-banded with kingwood and lacewood and inlaid with satin-wood banding and boxwood lines. Where there is uncertainty about the exact material, use a broad term (e.g., *wood, ceramic, metal*), or if there are only two or three possible materials, record them with appropriate qualification (e.g., *ash* or *elm*).

Typically, descriptions vary from those that simply list the materials and techniques employed (e.g., *painted papier-mâché and glass*), to ones that provide information about which parts of the object were made using which materials and techniques (e.g., *ivory drum and a silver-gilt embossed and chiseled mount*). Both approaches are useful, although the latter is of more value when it comes to visualizing, and therefore being able to identify, the object.

In the case of furniture, it is common practice to describe only the visible surface materials and/or the technique employed (e.g., *mahogany veneered, marquetry*) and not the secondary internal materials, even if they constitute the greater part of the object. Museums, on the other hand, often record both primary and secondary materials (e.g., *maple and yellow poplar with yellow and white pine*), while some record which parts of the object are made from which type of wood.

> **Example:**
> Black walnut case, doors, drawer fronts, top board on desk, and feet; pine drawer bottoms, sides, and backs.

Materials & Techniques can also be used to provide information about the color(s) of an object (e.g., *black chalk, pink plastic*). Some objects are of a single color, or a small number of dominant colors. In these cases, it is well worth recording the color(s), since they can provide an important means of identifying the objects. Many objects, however, such as most paintings, have so many colors that attempting to list them all is a time-consuming and pointless exercise.

Measurements

What is the size and/or weight of the object? Specify which unit of measurement is being used (e.g., cm, in.) and to which dimension the measurement refers (e.g., height, width, depth).

An object's measurements greatly assist identification. All measurements need to be recorded as accurately as possible, since inaccurate information might prevent an object from being identified. If accurate measurements are not possible—for example, if the description is made after the theft and the measurements must be estimated from a photograph—the information should include qualification (e.g., *approximately 175 cm, 50 cm [estimated]*).

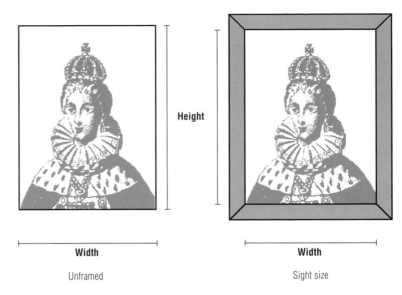

Figure 5 **When paintings, drawings, and prints are measured, the dimensions given should be height followed by width. These dimensions will differ depending on whether the unframed size or "sight size" is measured.**

When paintings, drawings, and prints are measured, the dimensions given should be height followed by width (e.g., *66 × 45 cm*). Unless otherwise specified, auction houses and dealers always record the "sight size" of the work—that is, the area visible within the frame rather than the overall size of the canvas, paper, or panel. Museums, on the other hand, often record the dimensions of the work unframed (see figure 5). Since frames are easily removed, the dimensions of the sight size of a work are not as valuable for purposes of identification as its dimensions unframed. Some institutions provide both sets of dimensions together with qualifying remarks, such as *height 51 cm, width 57.5 cm; unframed height 55 cm, width 61.5 cm.*

For sculpture, the height is invariably recorded and usually the width and depth as well. For works that are longer than they are tall, such as reclining figures, the length should also be given. Whenever possible, measurements should be taken at the highest and widest points, with qualification added (e.g., *250 cm to apex of finial*). For objects of irregular shape, where the highest or widest points are not clear, take measurements that can be understood by another person examining the object (e.g., *height 365 cm to point of spear, 358 cm to top of head, 98 cm across plinth* [see figure 6]).

The dimensions of furniture should include the height, width, and depth, in that order (see figure 7). Some measurements will require

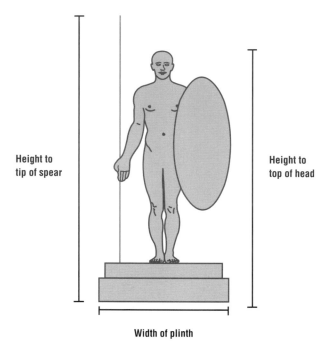

Height to
tip of spear

Height to
top of head

Width of plinth

Figure 6 **In the case of objects of irregular shape, measurements should be taken that can be understood and reproduced by another person.**

qualification (e.g., *width 250 cm with wings extended*). Appraisers, auctioneers, and dealers often provide only two or even one of the key measurements for certain types of object—for example, chairs, where common practice provides only the height of the back, or the height and width.

Circular objects such as plates and bowls should be recorded in diameter, whereas for tall and irregularly shaped objects, such as vases and ewers, the height should be given. For carpets, rugs, and tapestries, the length and width should be recorded, or the diameter if the object is circular. Most clocks are measured in the same way as furniture, although they may also be measured across the dial, for example, *height 305 cm (10'), width 56 cm (1' 10"), dial 46 cm × 76 cm (1' 6" × 2' 6")*.

The dimensions and/or weight of contemporary art installations may vary considerably. In these cases, a range of measurements or average or "ideal" measurements, should be provided.

Examples:

Size variable, ranges from 440 cm (14' 5¹/4") to 480 cm (15' 9").

Silver-cellophane-wrapped candies, endlessly replenished supply, ideal weight 1,000 lb. Weight varies with each installation. Dimensions variable.

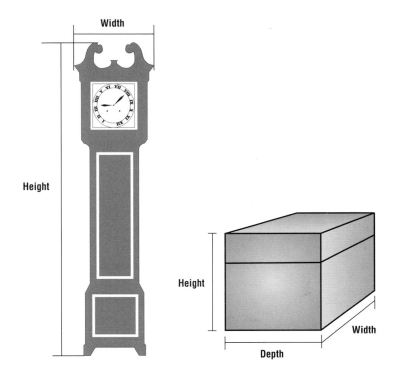

Figure 7 **The dimensions of furniture should include the height, width, and depth, in that order. Most clocks are measured in the same way as furniture, although they may also be measured across the dial.**

The weight of objects made of precious metals such as gold and silver is customarily recorded. Several units of measurements may also be included, such as grams (*gm*), avoirdupois (*oz*), and troy (*oz dwt*).

Inscriptions & Markings

Are there any identifying markings, numbers, or inscriptions on the object (e.g., a signature, dedication, title, maker's marks, purity marks, property marks)?

This category includes both text and markings that have been inscribed, cast, stamped, or otherwise applied or incorporated into the object at the time of manufacture or at a later date. It should include the location(s) of inscriptions and markings, for example, *inscription on frieze of plinth, maker's mark on base.*

Inscriptions & Markings can greatly assist in the identification of objects. They are particularly important in differentiating between a number of objects of similar appearance. The presence of a serial number

or the position of a maker's mark might be the only difference between the object in question and others like it. Recorded inscriptions and markings can assist in identifying the maker of an object, its place of origin, the date or period in which it was made, or the material of which it is made. They can even supply information about its provenance.

Textual inscriptions should always be recorded exactly as they appear on the object, including misspellings, although these should be followed by the qualifier *sic* in brackets to indicate that the incorrectness is as given in the inscription (e.g., *Spring Summer Autum [sic] Winter*). If an inscription is only partly legible, record the words/letters that can be read and indicate gaps (e.g., *Mytton wild [illegible] shooting* or *Mytton wild . . . shooting*). Where missing or illegible letters or words have been inferred, indicate the part of the inscription that is not visible on the object (e.g., . . . *ad fanum tuum [at]tulerint*). When the correct reading of an object is uncertain, add a question mark, except when recording signatures. A question mark attached to a signature will suggest that there is uncertainty about the attribution (see below). An inscription that is wholly illegible should be recorded as such (e.g., *signature illegible*).

Inscriptions should be recorded in the original language, although translations can be provided if desired.

> **Example:**
> docilianus bruceri deaesanctissime suli devoveoeum[.]ui caracellammeam inuolaueritsi uirsiferninasi seruussiliber ut[1–2]umdeasulis maximoletum [.]digatneceiso mnumpermit. This has been translated as: "Docilianus (son) of Brucerus [Brucetus?] to the most holy goddess Sulis. I curse him who has stolen my hooded cloak, whether man or woman, whether slave or free, that . . . the goddess Sulis inflict death upon . . . and not allow him sleep or children now and in the future, until he has brought my hooded cloak to the temple of her divinity."

If the inscription cannot be recorded as it appears on the object, for example, when it is in an ancient language or in pictograms, its presence should be recorded (e.g., *with pictorial cuneiform*). A translation of the text can also be given, if known (e.g., *inscription in runes on comb-case translates as "Thorfast made a good comb"*). In these cases a photograph, or photographs, should also be taken of the inscription to aid identification.

When documenting a mark, it is important to remember that non-experts are unlikely to be able to visualize it from a description that gives its meaning, but does not describe its appearance. For example, the information *Maker's mark of Pierre-François Drais, charge and discharge marks of Jean-Baptiste Fouache* does not tell a non-expert anything about the appearance of the actual marks mentioned. If possible, therefore,

describe the marks as well as interpreting them, for example, *four hall-marks: lion passant (sterling silver); rose (Sheffield, England); "ℋ" (1997); initials "PST" (Peter Scot Thornes)*. Close-up photographs or sketches of marks, and their positions relative to each other, may provide a unique means of identifying the object (see also **Distinguishing Features**).

A title that is engraved, carved, cast, or otherwise physically a part of the object should be recorded under both **Inscriptions & Markings** and **Title**. Many markings depict subject matter, ranging from simple designs (e.g., *anchor, lion, wheat sheaf*) to relatively complex images (e.g., *seated figure wearing long gown*). Descriptions of the subject matter of markings should follow the same approach as that recommended under **Subject**.

The recording of signatures, dates, and inscriptions can indicate whether they are believed to be authentic. For example, Christie's includes the text "*Signed . . .*"/ "*Dated . . .*"/ "*Inscribed . . .*" to indicate its opinion that the work has been signed/dated/inscribed by the artist, a question mark to indicate doubt about the attribution, such as *Signed Marc Chagall?*, and the qualification "*With signature . . .*"/ "*With date . . .*"/ "*With inscription . . .*" to indicate that in its opinion the signature/date/inscription is by a hand other than that of the artist.

Although inscriptions and markings provide useful information about the history of an object, they can also be misleading. Signatures can be added to paintings, and marks cannot always be taken at face value. For example, the crossed swords used by the Meissen porcelain factory from ca. 1722 were also used by English factories at Bow, Worcester, Derby, Lowestoft, and Coalport, deliberately to mislead customers. Equally if not intentionally misleading was the Chinese habit—especially during the reign of the Kangxi emperor (1662–1722)—of applying the mark of an earlier emperor as an act of reverence.[2]

Note on security marking

It is particularly important to record the presence and location of security markings using substances that are invisible to the naked eye under normal light (e.g., *zip code 20073 written with UV pen on underside of top right-hand drawer; Smart Water applied to stretcher; microchip concealed in frame*). Alerting law-enforcement agencies to the presence of these markings will enable them to test recovered objects using the appropriate technology, such as ultraviolet light for inscriptions written with UV marking pens and Smart Water™, and scanners for microchips.

Remember that security marking physically alters objects, may result in damage, and can adversely affect their value. When considering marking an object for security, first consult an expert for advice on whether to proceed and, if so, which is the best method to use.

Distinguishing Features (by Henry Lie)

Does the object have any physical characteristics that could help to identify it (e.g., damage, repairs, or manufacturing defects)?
An object's physical condition provides one of the best means of identifying it uniquely. This is particularly true when it is one of a number manufactured to a common design or when it closely resembles other objects of the same kind.[3] **Distinguishing Features** allows the recording of physical characteristics (e.g., scratches, creases, stains, drips in paint or glaze, bubbles, surface texture, etc.) that could help to uniquely identify an object. Such distinguishing features are typically small relative to the size of the object, and are usually the result of a chance event during the manufacturing process or minor damage sustained at a later date.

Recording distinguishing features
A combination of a narrative description, photographs, and sketches provides the best record of distinguishing features.

Narrative description has the advantage of requiring no special equipment, no photographic or artistic skills, and no need to add material, such as photographic prints, subsequent to the recording session. A written narrative can be incorporated into a database more easily than photographs or sketches. On the other hand, narrative descriptions are less precise than images, unless the recorder has highly developed descriptive skills. For this reason narrative text alone is not recommended to record a unique feature. Avoid one-word descriptions of the condition such as *good*, *fair*, or *poor* that do not identify an object or provide evidence for accountability in the event of damage in transit, in storage, or when on loan for exhibition.

When photographing distinguishing features, take care to select highly visible features and to record them precisely. Sketches can complement the written description and photograph of a distinguishing feature by locating it on the object and giving an impression of its form and extent. While simple sketches of unique features may take a few moments to conceive and produce, they may provide essential distinguishing feature information clearly and precisely.

Selecting a distinguishing feature
The nature of the object usually dictates the type of feature that should be selected. Ideally, the features chosen should be large enough to see with the naked eye. Structural components or elements of design in surface decorations should not be chosen as distinguishing features, since they are more likely to be repeated in similar objects, copies, or examples from an edition. In addition to the critical quality of uniqueness, the durability of the selected feature is an important consideration, if the record is to be valid over a long period of time. Some features may be removed or

obscured by accidental or intentional changes, such as cropping the edges from a paper object or a painting, varnishing a decorative surface, or polishing the surface of a metal object. Another consideration, in addition to the uniqueness and durability of features, is the relative ease with which they can be recorded and later recognized from the record made.

Works of art on paper

Typical distinguishing features for works of art on paper include tears, creases, abrasions, holes (losses), structural repairs, in-painting and other restorations, stains (present and removed), watermarks, edge patterns, cropping of edges, and the exact location and nature of collectors' marks and watermarks. Consistency of paper quality and the uniform procedures used to print multiple editions can produce objects that are very difficult to differentiate. Because of the great similarity among many multiples, it is wise to select and record at least two features.

Paintings

While paintings present fewer challenges than multiple editions, some painting styles lend themselves to the production of exact copies, which can be difficult to distinguish from one another. In such cases, even design elements may not record uniqueness. More useful features include crackling in the paint surface, distinctive brush strokes, damage or losses, repairs, irregularities at the edge of the canvas, and the pattern of paint at the periphery of the paint area. When the artist paints with a dynamic technique that results in a distinctive pattern of brushstrokes, the photographic details of design elements can constitute a reliable and easily located set of unique features. The reverse side of a painting can also provide an excellent and often overlooked source of information, such as signatures, inscriptions, stains, stamps, damages, or unique aspects of the fabric support. See **Textiles** below for further comments on fabric.

Both paintings and paper objects are vulnerable to being cut down in size, so recording only features located at the object's edges is unwise. Similarly, because restorations are subject to change over time, they should not be used as the sole means of establishing a record. Moreover, restorations on many paintings are nearly invisible and can thus be difficult to record. The best distinguishing features are those occurring in areas least subject to loss or alteration.

Metals

Cast metal objects often belong to editions of multiples. As with prints on paper, care should be taken to select distinguishing features unique to an individual casting rather than to the model from which it is derived. Tool impressions made on the surface of the metal after casting can offer unique characteristics for recording purposes.

Casting flaws, such as air bubbles or larger voids in the metal, and the applied metal patches often used to repair them, offer suitable distinguishing features, as can chance patterns caused by the flow of metal during casting. Cast and non-cast metal objects have many features in common. Deep or highly visible scratches and abrasions, dents, and irregularities in welds or other types of mends or joins can all provide unique characteristics for recording purposes. However, it is important to remember that there is a danger of some recorded features being eradicated at a later date by polishing and reworking of the surface, painting and repatination, or application of protective coatings.

Glass and ceramics

The highly uniform production methods for glass and ceramic objects can result in artifacts that are difficult to distinguish from one another. Chips, larger losses, cracks, glaze crack patterns, bubbles, scratches, abrasions, repair locations, and areas of irregular surface texture or coloration can be used to create records for accurate identification. When intentional features of the design are substantially irregular, these too can be used.

Wood

Wooden objects are often unique and offer a wide variety of distinguishing features. In addition to many of the damage-related features mentioned above, wooden objects may often exhibit pronounced grain structure, irregularities in joinery, irregular details of incised or carved surface decorations, and saw-mark patterns. Details of decorative surface coatings and inlay work also provide unique characteristics appropriate for identification records, unless they happen to be highly uniform.

Textiles

Machine-made and even handwoven fabrics are often produced with great uniformity. Irregularities in the assembly of separate components may provide a degree of uniqueness in some cases. Losses, tears, wear patterns, irregularities in the weave or fiber, repairs, stains, and the irregular application of colorants are the most likely features for selection for this purpose. These features apply as well to the backs of paintings on canvas.

Recording the location of the distinguishing feature

The location of the distinguishing feature selected should always be recorded. Annotating the location of the distinguishing feature on an overall photograph is the preferred technique of recording its location, or by adding the information to the written description or sketch of the object. As with the descriptions of the features, the more concise and precise the location description, the more useful it is likely to be.

Note on security

In the case of well-known works of art of high value, the existence of documented distinguishing features should not be made public knowledge, either before or after a theft. Descriptions and photographs of these features provide the owner/custodian and the police with information not known to individuals who may claim to possess the object in an attempt to obtain a ransom under false pretenses. Any individual can claim to have an object and may be able to provide dimensions and a description of its subject matter from published sources. Only the person in possession of it will be able to answer questions such as *"What can you see on the top left-hand corner of the rear of the canvas?"*

Title

Does the object have a title by which it is known and might be identified (e.g., The Scream*)?*
The title of an object is a word or phrase by which the object is known and may be identified. An object may be given a title either at the time of its creation or at a later date. Some objects are known by more than one title, such as *Las Meninas* (artist's title) and the *Maids of Honor* (popular title). Moreover, the title by which an object is known in one country may be different from that of its country of origin (e.g., *Skrik* and *The Scream*).

The title is sometimes physically part of an object (e.g., carved or cast into the base of a statue, or engraved onto an etching). In these cases the title should also be recorded under **Inscriptions & Markings**.

A title may or may not indicate the subject matter depicted or represented. For example, the title *A Pool Surrounded by Trees* indicates the subject matter depicted, but *Number 14* does not. Thus, the former should also be recorded under **Subject**.

Subject

What is pictured or represented (e.g., landscape, battle, woman holding child)?
A description of any subject depicted or represented is potentially one of the most important ways of identifying an object or finding an image of it. However, describing subject matter in a way that is useful to others is one of the most difficult parts of the documentation process.

Different individuals may describe the same subject matter in different ways. The point is made by this true story: An oil painting recorded on a law-enforcement database, but not matched with a recovered painting,

was interpreted differently by two individuals. A view of the city of Lincoln, England, with the cathedral looming above the houses, was described by the creator of the record as a *townscape*, while the person who searched for it used the term *cathedral* and did not find the painting. Both persons were correct, but both provided only part of the information necessary to enable matching identification to be made.

In descriptions of subject matter, the recorded information should be self-explanatory to anyone without specialist or culturally specific knowledge. For example, experts might identify a statue of a man wearing a lion skin and holding a club as a depiction of *Hercules* and a Hindu representation of an eagle as *Garuda*, but those not familiar with classical mythology and Hindu culture may not understand the references. One way around this problem is to describe the subject matter in both specialist and non-specialist terms, combining that which is actually visible with its meaning (e.g., *Marsyas | naked male figure with arms above head, bound hand and foot*).

Subject matter can be recorded in two ways: It can take the form of a textual description that enables others to visualize the object, particularly useful if there is no photograph of the object, or it can be recorded as a series of keywords, a useful approach when searching for the object in a retrieval system (see discussion under **Type of Object** above).

The keyword approach calls for a controlled vocabulary (e.g., *interior scene, figure[s], animal[s]*), which permits more accurate retrieval of records. This approach is also well suited to multilingual databases, since individual keywords can be coded and linked to their equivalents in other languages. The disadvantage of the keyword approach is that it can limit users to a relatively small number of choices and cannot convey information as nuanced as the textual description. However, the two ways of recording subject matter can be complementary. A number of systems record subject matter both as free-text descriptions and as keywords.

The most extensive iconographic classification system for describing subject matter is ICONCLASS (www.iconclass.let.uu.nl), a database that provides a collection of ready-made definitions of objects, persons, events, situations, and abstract ideas. The ICONCLASS hierarchy is divided into ten basic classes intended to comprise all the principal aspects of what can be represented: Religion and Magic (1), Nature (2), Human Being, Man in General (3), Society, Civilization, Culture (4), Abstract Ideas and Concepts (5), History (6), Bible (7), Literature (8), Classical Mythology and Ancient History (9), and Abstract Art, Non-representational Art (0). The notation codes used are alphanumeric, with one digit added for every level in the hierarchy.

Example:

A seventeenth-century Dutch print entitled *"House built upon a rock, house built upon sand,"* depicts *landscape with castle on rock; windmill in background.* Its ICONCLASS classification reads as follows: *rock-formations (25H1123), castle (41A12), windmill (47D31),* "house built upon a rock; house built upon sand" doctrine of Christ on love (Matthew 7:24-27; Luke 6:47-49)(73C7455).

Date or Period

When was the object made (e.g., 1893, early seventeenth century, Late Bronze Age)?

Relatively few objects can be dated with precision. It is common, therefore, to indicate age by date ranges (e.g., *1876–1878*), parts of centuries (e.g., *third quarter of the eighteenth century, late fourteenth century*), regnal or dynastic periods (e.g., *Victorian, Yuan dynasty*), or cultural periods (e.g., *Neolithic*). No agreed rules exist for the terms used to qualify dates, but the following suggestions are offered as a guide:[4]

probably	for fairly certain dates
circa (ca.)	ten years on either side of the date
flourished (fl.)	twenty years on either side of the date (describing the maker not the object)
before	up to one hundred years before the date given
after	up to one hundred years after a date

When date ranges (sometimes called date spans) are used, the first date should be the earliest date, within reason, that the object could have been made and the latter the latest possible date. Period names specific to one country (e.g., U.S. *Federal*, U.K. *Regency*) are best avoided when providing information for international circulation.

Some objects may have been created in one period and substantially altered at a later date. In these cases both the date or period of creation and the date or period at which the alterations were made should be recorded (e.g., *early seventeenth century, reworked 1879*). An object or objects made in one period may be incorporated into an object made in another, as is the case with the gold intaglio bracelet mentioned earlier at the end of **Type of Object**: *Gold intaglio bracelet set with thirteen cornelian and hardstone intaglios, mostly Roman first to third century* A.D., *the intaglios mounted in gold, ca. 1820.* In these cases, all relevant dates should be provided.

Maker

Do you know who made the object? This may be the name of a known individual (e.g., Thomas Tompion), a company (e.g., Tiffany & Co.), or a cultural group (e.g., Hopi).

Knowing the name of the **Maker** can help to narrow a database search to objects made by that person, company, and so on. Moreover, associating an object with a named individual can greatly enhance its historic significance and in some instances its value. However, the retrievability of this information depends on the use of the same form of spelling by the person who documented the object and the person searching for it. For example, the name of the painter *Gerrit van Honthorst* would be searched for by a Dutch person using this "preferred" form of his name, while an Italian would most likely search using *Gherardo delle Notti* (see figure 8).

One way of ensuring consistency is to use only "preferred" versions of names (see discussion of preferred terms in **Type of Object**). Some organizations achieve this by using a published reference work such as Bénézit's *Dictionnaire des peintres, sculpteurs, dessinateurs et graveurs*[5] as their authority.[6] A more flexible approach uses the on-line, structured vocabulary tool *Union List of Artist Names* (ULAN). ULAN (www.gii. getty.edu/vocabularies/ulan) is a database of biographical and bibliographical information on artists and architects, including variant names, pseudonyms, and language variants. It can be used as an authority file (see **Type of Object**) and as a searching tool that enhances retrieval of multiple versions of names.

Some objects have more than one maker (e.g., a clock made by *Thomas Tompion and Edward Banger*). Sometimes the different roles played by individuals in the creation of an object are also known (e.g., *artist: Charles le Brun; engraver: Michel Corneille, Francesco di Giorgio Martini; reworked by Baldassare Peruzzi*). In the case of mass-produced objects, it may be possible to give only the name of the factory (e.g., *Wedgwood*). In

Honthorst, Gerrit van [BA,GC,JG,PR]
 (Dutch artist, 1590-1656)
 Gerard Honthorst
 Gerrit van Honthorst
 Gherard Honthorst
 Honthorst, Gerard van
 Honthorst, Gerhard
 Honthorst, Gerrit
 Honthorst, Gerrit or Gerard van (Gherardo della Notte or delle Notti, or Gherardo Fiammingo)

Union List
of Artist
Names*

Figure 8 **The *Union List of Artist Names* (ULAN) is a database of biographical information on artists and architects, including variant names, pseudonyms, and language variants. Shown here is the entry for Gerrit van Honthorst.**

other cases, the names of designers may be known and their work so distinctive that they are more useful for purposes of identifying an object than the name of the company that actually made the object (e.g., *designer: Clarice Cliff; manufacturer: A.J. Wilkinson Ltd.*). The maker may also be recorded as the tribe or people to whom an anonymous maker belonged (e.g., *Vuvi tribe, Gabon* [see also **Place of Origin/Discovery** below]).

In the art trade, attributions of responsibility are of considerable importance—they enable one to say that an object was created by a particular individual, thereby greatly enhancing its value. Where attribution is certain, the maker's name can be stated without accompanying qualifications. However, if the attribution is not certain, it needs qualification. Degrees of certainty are expressed using terms such as *attributed to* (when the attribution is relatively certain), *school* or *atelier of* (when the object was made by someone working within the circle of the named person), *follower of* (when the object was made by someone working close to, but not within the circle of the named person), or *after* or *style of* (when the object's maker comes later and had no direct contact with the named person). In addition, the name may have been given posthumously to an anonymous individual with a recognizable style and to whom objects have been attributed (e.g., *the Painter of Athens*).

Many auction catalogues now explain the company's attribution policy by means of glossaries, which qualify the relationship between the object and the named person in the catalogue. The following conventions for attribution are used by Sotheby's:

> **Giovanni Bellini:** In our opinion a work by the artist. When the artist's forename(s) is not known, a series of asterisks, followed by the surname of the artist, whether preceded by an initial or not, indicates that in our opinion the work is by the artist named.
>
> **attributed to Giovanni Bellini:** In our opinion *probably* a work by the artist but less certainty as to authorship is expressed than in the preceding category.
>
> **studio of Giovanni Bellini:** In our opinion a work by an unknown hand in the studio of the artist, which may or may not have been executed under the artist's direction.
>
> **circle of Giovanni Bellini:** In our opinion a work by an as yet unidentified but distinct hand, closely associated with the named artist but not necessarily his pupil.
>
> **style of.......; follower of Giovanni Bellini:** In our opinion a work by a painter *working in the artist's style,* contemporary or nearly contemporary, but not necessarily his pupil.

manner of Giovanni Bellini: In our opinion a work in the style of the artist *and of a later date.*

after Giovanni Bellini: In our opinion *a copy* of a known work of the artist.

The term **signed** and/or **dated** and/or **inscribed** means that in our opinion the signature and/or date and/or inscription are from the hand of the artist.

The term **bears** a **signature** and/or **date** and/or **inscription** means that in our opinion the signature and/or date and/or inscription have been added by another hand.

"With signature . . ."/ "With date . . ."/ "With inscription . . .": In our opinion the signature/date/inscription is by a hand other than that of the artist.

In the case of known artists, their life dates provide added value, for example, *Jean Laurent Mosnier (1743–1808).* If their locus of activity is known, this may also be recorded, for example, *Philips Wouwerman (1619–Haarlem–1668).* Where the artist had more than one principal locus of activity, this may be indicated, for example, *Francesco-Giuseppe Casanova, London 1727–1802 Vienna; Bartholomeus Maton, Leiden ca. 1643–46—after 1684 Stockholm.* (See also **Place of Origin/Discovery** below.)

Description

The Object ID checklist recommends that, in addition to providing the information covered in the preceding categories, users write a short description that can include further information to help identify the object. Descriptions can be written in two ways: to record information not covered in other categories, or to summarize the information recorded under other categories in a unified entry.

Non-experts may wish to confine the description to new information, answering the following questions to the extent that the information is known:

1. What does the object look like, what are its colors and shape? Are there other attributes not recorded elsewhere in the record?
2. What is the object's place of origin, its provenance, the history of its ownership? Has it ever been exhibited?
3. Has anything been written about it?

Experts, on the other hand, often use the description to summarize all information of relevance in a unified entry. For example, auction-

eers and dealers commonly include the following list of information in their descriptions of paintings. While the order may vary among organizations and even departments, it is important to be as consistent as possible in terms of both the format and the order of the information within a given set of records:

1. Name of the artist
2. Artist's dates and sometimes locus of activity
3. Materials and techniques
4. Measurements ("sight size," see **Measurements**)
5. Title, or subject if there is no title
6. Indication if the painting is signed and dated
7. Provenance, literature, and exhibition history

Example:
Theobald Michau
(Tournai 1676–1765 Antwerp)
The Fortune Teller
Oil on panel, 33.6 × 48.2 cm
Signed

PROVENANCE
John Theobald Michau
Mitchell & Son, 1966
Private collection, U.K.

In the case of furniture and many other types of objects, the emphasis is less on the maker and more on the appearance of the object. The following is typical of the information provided, although the order in which it is given varies:

1. Descriptive phrase that can combine style/period of manufacture, the type of object, and principal material(s)
2. Materials and techniques used, together with a description of the object's appearance
3. Place of origin
4. Maker's name
5. Measurements
6. Provenance and literature

Example:
Baroque cupboard in Caucasian walnut, veneered pine, with doors divided into four mirrored sections, parquetry in walnut, root, fine-grained myrrh, and cherry
234 × 197 × 75 cm
Germany, Mainz-Kurpfalz, ca. 1750

In the antiques trade, it is usual to describe items of furniture from the top down, starting with the upper surface and working down to the legs.

Example:
crossbanded plank top with re-entrant corners. The frieze with one long drawer above three short drawers, all with their original handles. Standing on bifurcated legs with pad feet.

Descriptions of jewelry can include the materials (e.g., *diamond, topaz, bronze, gold*) and, where appropriate, their purity (e.g., *18 carat*), the ways in which any stones are cut (e.g., *brilliant, baguette, Swiss*), the positions of inclusions, the forms of settings (e.g., *scroll, scallop or arcade, organ pipe*), maker's marks and purity marks, names of designers and or makers, place and date of manufacture, and other constructional and decorative techniques employed, as well as any subject matter depicted.

The written description should also qualify any information about which there is a degree of uncertainty.

Examples:
According to tradition this decorative ship carving came from the packet ship, *Congress.*

. . . probably to commemorate the marriage of Philip Papillon (d. 1736).
. . . possibly owned by George Parnall, mayor of Hereford in 1660.

While the description should create a picture of the object in the mind's eye of the reader, in reality it is not always easy for non-experts to visualize an object from the description alone. This is why photographs are of crucial importance. The written description and the accompanying photographs should be complementary—the photograph illustrating the features described by the written record, and the written record providing the information about the object's physical characteristics and history that cannot be gained from the image alone.

In the writing of descriptions, specialist jargon should be avoided, as should non-specific adjectives such as *interesting, old, rare,* and *important.*

In addition to providing the information recommended by Object ID, the description can also be used to summarize the history of the ownership of the object (its provenance), its exhibition history, and any literature concerning it (see **Related Written Material**). These categories do not greatly assist the process of identifying an object, but can be

of great value when it comes to proving ownership—particularly when title is disputed.

Ideally, a complete record of the provenance of an object includes all owners from the time it left the maker's possession to the time it was acquired by the present owner.[7] In addition to the names of owners, the record may include their places of residence, the dates of their ownership of the object, methods of acquisition, uncertainty or lapses in provenance, and any other information regarded as relevant. The history of the ownership of an object can, therefore, provide useful evidence, not only about former owners, but also, by extension, about the location of the object throughout time.

Example:

Robert Smythson (England, ca. 1535–1614); John Smithson (died 1634); Huntingdon Smythson (died 1648); John Smithson the Younger (1640–1717); . . . sold by the 5th Lord Byron at Newstead Abbey, Nottinghamshire, June 1778, lot 344; there bought by the Rev. D'Ewes Coke of Broke-hill Hall, Derbyshire; by descent to Mrs. S. Coke of Broke-hill Hall, from whom the drawing was purchased by the Royal Institute of British Architects in 1927.

The exhibition history of an object provides the names, locations, and dates of any exhibitions at which the object is known to have been shown (e.g., *Exhibited: Paris, Grand Palais, Salon [Société National des Beaux Arts], 1914*). If an exhibition catalogue was produced, this can be recorded in **Related Written Material** (see **Additional Recommended Categories**).

Notes

1. Strictly speaking, a *clock* is a *timepiece* that strikes the hour, quarter hours, or, in the case of ships' clocks, the watches. A *timepiece* that does not strike should be called by that name rather than being described as a *clock*.

2. See the *Dictionary of Art*, Vol. 20, 440–46, for a discussion of the history of marking.

3. Distinguishing Features is the result of a collaboration between the Getty Information Institute and the Getty Conservation Institute. In August 1994, the two institutes organized a Conservation Specialists Working Group that met in Washington, D.C., to examine the ways in which physical characteristics could be recorded for identification. The participants agreed on the need for the proposed standard, which they believed should include both written and visual information. The need for a category called "Distinguishing Features" emerged as a key recommendation of the meeting. Its purpose would be to record

information about an object's physical characteristics that could help to identify it (e.g., damage, repairs, or manufacturing defects). The importance of Distinguishing Features was vindicated by all the questionnaire surveys carried out after that date.

4. See V. Porter and R. Thornes, *A Guide to the Description of Architectural Drawings.*

5. E. Bénézit, *Dictionnaire des peintres, sculpteurs, dessinateurs et graveurs.* Paris: Gründ, 1976.

6. An authority list or file provides approved terms or versions of names, enabling information to be recorded in a controlled manner for ease of entry and retrieval. Types of authority files/lists include name authority lists, subject authority lists, and thesauri. They may also include notes on local usage.

7. Provenance is sometimes defined differently when it is used in an archival context. In this case, it refers to the person or corporate body that created or gathered together a body of documents. Archival descriptions often do, however, include the use of provenance in the sense used here when a group is donated or purchased.

Additional Recommended Categories

Of the categories of information not selected for Object ID because there was no clear consensus in favor of their inclusion, five were regarded as being important by a majority of respondents in at least four of the six communities surveyed. These categories of information are **Inventory Number**, **Related Written Material**, **Place of Origin/Discovery**, **Cross Reference to Related Objects**, and **Date Documented**. Anyone recording information about cultural objects should consider including these categories.

Inventory Number

The **Inventory Number** is the name used by this guide for the accession numbers, catalogue numbers, or registration numbers used in many museums and collections. Sometimes these numbers are written, painted, or stamped on the objects. The purpose of these identifiers is to connect an object to its documentation and distinguish it from other objects within the same collection, museum, or other repository. They can be simple numbers or may comprise various types of information, including the acronyms of the organization and the date the object was acquired or accessioned (e.g., *1989.25.1, RIBA X/19*). It is important to remember that although an **Inventory Number** can uniquely identify the object within the institution that holds it, it may not uniquely identify it in the event of theft if other organizations use the same numbering system. If the identifier has been inscribed on the object, it should also be recorded under **Inscriptions & Markings**.

Related Written Material

This category provides references, including citations, to other written material related to the object, such as published information and/or specialist reports concerning the object's significance, provenance, exhibition history, conservation history, scientific tests, contextual information about

its maker, or references to standard texts. In the surveys undertaken to identify the categories to be included in Object ID, **Related Written Material** was believed to be important by 93 percent of the appraisers surveyed, but regarded as less important by the other communities. An alternative is to include this information under **Description**.

> **Example:**
> Literature: P. L. W. Arts, *Japanese Porcelain*, Lochem:
> De Tijdstroom, 1983, p. 51, no. 25.

Place of Origin/Discovery

This category indicates the name of the place where the object was made or, in the case of archaeological finds, the location where it was discovered. It is recorded with varying degrees of precision, depending on the information available. The location given can be the name of an archaeological site, a city, part of a country, a country, a tribal area, or a region of the world. Once again, this information can also be recorded under **Description**.

Of course, the place the object was made might not be the same as the place of discovery. For example, many objects excavated at Roman sites originated in other countries formerly within that empire. Moreover, it is not uncommon for objects made in the same style to be made in a number of countries. For these reasons it can be difficult to identify the countries from which illegally excavated objects were taken. For example, the Sevso Treasure—comprising fourteen pieces of fourth-century Roman silver—has been claimed by Croatia, Hungary, and Lebanon.

It is important not to confuse the style in which an object was made with its place of origin. If an object is described as being in the *Greek style*, this does not mean that it necessarily originated in Greece. Similarly, an object said to be in the *French taste*, is not necessarily French. Style is often used instead of place of origin when the latter is not known.

Cross Reference to Related Objects

The historical interest of some objects may partly result from their relationship to other objects. It is this relationship that **Cross Reference to Related Objects** is designed to record.

> **Examples:**
> A closely similar example is in the British Museum, London.
>
> This cabinet may be compared with a similar piece in the Musée Guimet, Paris, and another larger piece in the Dr S.Y. Yip collection, Hong Kong.

Date Documented

The **Date Documented** is the date on which the description of the object was made. From the appraiser's point of view, no appraisal is valid without the date the object was documented, together with the name of the creator of the documentation. Evidence of an object's appearance at a given date could be of value if the object is altered or damaged in some way at some point in the future. This category can also be important for establishing ownership, by proving that an object was in the possession of an individual or organization at a particular date.

Part II Photographing Objects for Purposes of Identification

By Peter Dorrell

Overview

When it comes to identifying objects, a photograph is said to be worth a thousand words. In reality, the amount of information communicated by a photograph depends to a large extent on the clarity of the image, the way it is lit, and the viewpoint of the photographer. Part II of this publication is designed to assist those who photograph art, antiques, and antiquities by giving advice on choosing viewpoints, creating backgrounds, and positioning lighting to achieve the best results.

Choosing Viewpoints

Before an object is photographed, the first step is to choose the viewpoint, or viewpoints, from which to record it. In making the selection, the aim is to capture the maximum amount of information about the object.

For two-dimensional objects such as paintings, the camera should be square-on to the object. Spirit and bubble levels can be used to ensure the precision of the camera position. Paintings, prints, and drawings are not easy to photograph, given the need for even lighting and correct alignment of camera and object. Subtle lines, tones, or hues of objects such as watercolors and silverpoint etchings may be virtually impossible to reproduce exactly using an ordinary camera, lighting, and film processing. Often the best that can be done is to aim for a good overall impression, although photographs of distinguishing features, such as details of irregularities and damage, are essential for identifying the object uniquely. Manuscripts can be recorded in much the same way. They must be handled with great care. If they, or any other originals, are bound in a volume, photographs should be taken with the volume opened only to a 90-degree angle in order to avoid damage to the spine.

Objects made of fabric should be treated in the same way as paintings, in that the viewpoint should be exactly at right angles to the center of the piece. Not only will this show the details in their correct proportions, it will also capture any irregularities of shape, often an important feature with objects such as rugs. Such a viewpoint may be difficult to achieve with large carpets, as they may be too fragile to hang on a wall, and an overhead viewpoint would mean using an elevated platform or similar device. In all cases, the safety of the object and of the photographer should be the primary considerations.

Multisided objects, such as pieces of furniture, should be photographed from a three-quarter view, i.e., from above showing a corner, the top, and two sides. Important objects should also be photographed square on to the front, back, sides, and top, all the photographs being taken from the same distance and in similar lighting (see figure 9).

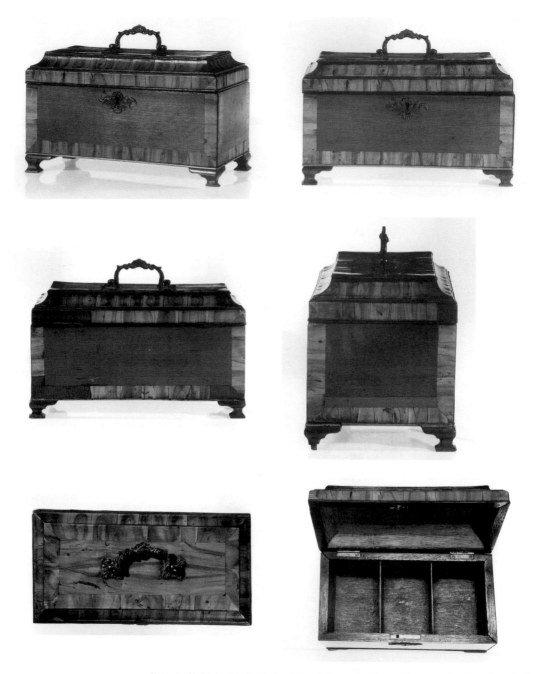

Figure 9 **Multisided objects should be photographed from a three-quarter view. Important objects should also be photographed square-on to the front, back, sides, and top, and, where applicable, to show the interior.**

It is less easy to suggest the most useful viewpoints for photographing freestanding statuary of a less formal kind. Because a slight change of viewpoint may reveal the shape of one feature but conceal another, the object should be examined carefully to select the most informative perspective. Ideally, a series of photographs should be taken from different viewpoints around the object. Where applicable and feasible, it is often valuable to take photographs to show any inscriptions, markings, or damage on the base of the object (see **Distinguishing Features**).

Carvings or castings in relief should be photographed from a frontal position in order to record the proportions, but additional photographs taken from slightly angled viewpoints will help to record the depth of the relief. Again, a photograph from below will record any inscriptions, markings, and damage.

For objects such as bowls, jugs, and vases, the most informative viewpoint is gained by looking down at the vessel from a slight angle, so that the rim appears as a shallow ellipse (see figure 10). For such things as shallow platters or bowls with interior decoration, two photographs may be necessary: one from very slightly above to show the profile and base of the vessel, the second from almost overhead to show the interior and inside of the wall. If the vessel has surface decoration, it may be appropriate to take several exposures, turning the vessel between each, but keeping camera and object in the same relative positions. Selecting the most definitive record shot can be done later.

Figure 10 **For objects such as bowls, jugs, and vases, the most informative viewpoint is one looking down from a slight angle, so that the rim appears as a shallow ellipse.**

Figure 11 **Objects such as paperweights and cameos should be pho-
tographed almost from above, with the viewpoint lowered
just enough to allow the depth or relief to be seen.**

With objects such as paperweights and cameos, the most infor-
mative viewpoint is almost from above, with the viewpoint lowered just
enough to allow the depth or relief to be seen (see figure 11). If the object
is in pieces, arrange the fragments in the same relative positions as they
would be in if it were whole.

Scales and information labels

All record photographs should include a scale of appropriate size. The
scale should be placed close to, but not overlapping, the object. It is
important to make sure that the scale is in the same plane as the object—
in the case of three-dimensional objects about halfway back in its visible
depth. This position will not only indicate the size of the object most
accurately, but (if the scale is focused sharply) will ensure that the object is
centered in the depth of field. A scale should include the unit and length
of measurement (e.g., *cm, in.*) printed on it, since a simple black-and-
white stick of unknown length is of little value. In addition, the photo-
graph should, if possible, include a gray scale or color reference card that
can be used to correct the screens or colors of an image when printing or
scanning (see figures 12 and 13).

Figure 12 **Photographs should, if possible, include a scale and color reference card of appropriate size.**

Figure 13 **The Object ID checklist, photographic scale, and color reference card. These pocket-sized cards have been produced by a number of organizations, including the Art Loss Register (London and New York), Nordstern Fine Art Insurance (international), and Mannheim Insurance (Germany).**

Creating Backgrounds

For standard record photographs in black-and-white, the most effective and informative backgrounds are either black or white. The background material can be an ordinary roll or sheets of paper or flexible matte-surfaced plastic. For use outdoors and for uncleaned objects, such as archaeological materials, plastic is preferred, being washable and less likely to tear. A neutral, unobtrusive background is usually best when photographing a painting, print, or drawing, whether for black-and-white or color. An exception might be when photographing an object where it may be important to define the edge of an object as clearly as possible. In this case a contrasting background might be preferable. At the same time, some professional photographers prefer to photograph objects with reflective surfaces, such as silverware, against white backgrounds. White backgrounds also act as a useful check on the color balance of the film, since if the white is reproduced as truly white, then it is reasonably certain that the colors are correctly recorded. However, white should definitely be avoided if the photography is for color transparencies intended for projection, since white backgrounds are apt to glare on the screen. Black backgrounds are apt to swallow the edges, and thus the shape, of an object unless the lighting is very skillfully arranged. Black backgrounds should also be avoided if the photograph is intended for publication, because print reproduction processes rarely produce smooth areas of solid black. Very intense saturated colors distract the eye from the object. If the image is copied to black-and-white, an intensely colored background will appear very dark. Also, reflection from a strong background can tinge the object with its color.

The majority of metal objects falls into one of two groups: smooth shiny objects of gold, silver, brass, polished steel, plate, pewter, and the like, and darker rough-surfaced metal objects of cast or wrought iron, bronze, and sometimes copper, although there are, of course, many intermediate cases. For black-and-white photography, the first group is best shown against a black cotton velvet background. Color photographs

can be taken against either, or against a colored background, although strongly colored backgrounds should be avoided.

When photographing ceramics in black-and-white, the objects are best positioned against black or white backgrounds, although usually white is better. Fabric, cartridge paper, or plastic sheeting make suitable backgrounds for ceramic objects. If possible, the object should stand on a glass or rigid plastic raised above the horizontal surface. White, black, or colored backgrounds will serve for color photography, making sure that light reflected from a colored background does not give a color cast to the object.

Coins and similar small objects with surface relief can be photographed against black, white, or colored backgrounds. If possible the object should be raised a centimeter or so high above the surface on a column of plasticene or modeling clay, so that the background is out of focus. (Care must be taken, however, not to place any fragile object on plasticene or a similar material that might stain or lift off its surface.) The simplest white background is either a light box or a sheet of glass held above a white illuminated surface (see figure 14). However, white backgrounds created using light boxes should be avoided when taking color photographs, because the fluorescent tubes may give an unpleasant blue-green color to the image.

Figure 14 **The simplest white background for small objects is either a light box or a sheet of glass held above a white illuminated surface.**

With such objects as pierced brooches, it is essential to be able to see the piercings clearly. This is more easily achieved with an illuminated background. Colored backgrounds can be used, but if the object is placed on a glass sheet above a colored background, particularly a dark color, there may be strong reflections in the glass. For very small objects, which could not be raised above a black, fabric surface, ordinary black carbon paper gives a good matte black.

Glass is notoriously difficult to photograph, partly because of reflections, but also because its transparency makes it difficult to distinguish detail on the front of the object from that showing through from the back. If the overall shape of the vessel is its most important characteristic, it is best photographed against a light background. If the surface detail is more important, it should be put against a somewhat darker one. For simple cast or blown glass, a background of translucent plastic or paper with a strong light behind it is often the most effective background (see figure 15). When photographing glass with color film, it is usually best to avoid a colored background; otherwise the object will appear to be the same color as the background.

Some statues and pieces of sculpture may have to be photographed in place, with little choice of position or viewpoint. When there is no choice about the background of such pieces, the setting should also form part of the photograph. It may be possible to make some adjustment to the background; for example, a sheet could be hung behind the statue, or—by eliminating the background lights—it could be isolated against a darker background. Movable objects can be positioned to allow the best conditions for photography, and smaller pieces can be treated like similar objects, with only the dullest background colors being used, placed well behind the object to avoid a color cast.

The background against which furniture is photographed will depend to some extent on the size and type of the individual object.

Figure 15 **For simple cast or blown glass, the most effective background is of translucent plastic or paper with a strong light behind it.**

Larger pieces may have to be photographed in place with no option of choosing a background. If the piece is small enough to be safely moved, the ideal placement is against a light background, with the object placed well in front of it. Defining the shape of the back and base is often a problem, and the problem is made worse if these parts are in shadow. Since nearly all furniture is wholly or partly freestanding, however, it may be possible to slide a sheet or light paper or fabric behind and under it (see figure 16). Such a background might be patchy or discontinuous, but this is preferable to having the piece disappear into darkness.

The type of background used for textiles should be determined by the tone or color of the object: light backgrounds for dark materials and darker backgrounds for light ones. If the material is open-textured, such as loose-woven cloth or basketry, an illuminated background can be effective. This can be either a light box or a sheet of glass raised above a separately illuminated sheet of white paper. If such material is photographed flat on a sheet of paper, of whatever tone, the edges of the weave are very likely to be lost in their own shadows. For color photography, a neutral or colorless background is preferred. This is particularly true with open-textured pieces, as a colored background might show through and dominate the result.

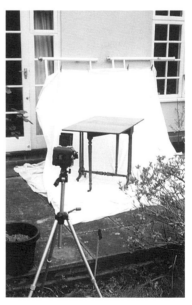

Figure 16 **When photographing a large object, such as a piece of furniture, it may be possible to slide a piece of fabric behind and under it to create a uniform background.**

Positioning Lighting

Artifacts and small objects can be photographed by daylight, although direct sunlight can produce both overlit and deeply shadowed areas that may obscure important details. Direct sunlight may be diffused by placing a piece of neutral muslin stretched on a frame between the object and the sun; a reflector can help cast light into the shadows.

Many cameras have built-in flash guns, while others have a fitting for a flash known as a hot shoe (see figure 17). On many 35mm single-lens reflex cameras (SLRs), the shoe is above the lens, with the result that the light emitted by the flash reflects straight back into the lens, resulting in patches of glare (hot spots) appearing on photographs of objects with shiny surfaces (e.g., varnished paintings, glass surfaces, or porcelain). Attaching the flash to a separate flash bracket to one side of the camera can reduce the amount of reflection (see figure 18). If the flash gun has an adjustable head, the brightness of the light can be softened by bouncing the light off an angled piece of white card positioned above the flash (see figure 19). In addition to general-purpose flash guns, a number

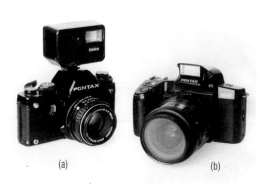

(a) (b)

Figure 17 **Cameras with (a) a flash unit fitted on a hot shoe attachment, and (b) an integral pop-up flash unit.**

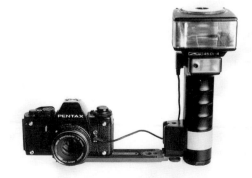

Figure 18 **A hammerhead flash unit mounted to the side of a camera using a flash bracket.**

Figure 19 **A flash unit on a bracket with a reflector.**

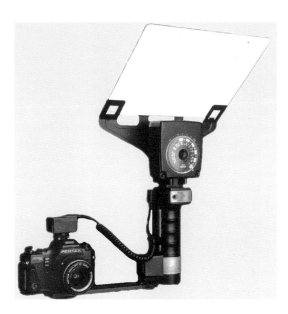

of more specialized types are available, including the ring flash (a circular flash unit that fits around the outside of the front of the lens), most often used in close-up photography of small objects such as coins, to produce localized, shadow-free lighting (see figure 20).

For black-and-white photography, two domestic desk lamps with ordinary incandescent bulbs can be used with, if possible, a third lamp to light the background (see figure 21). However, with color film, these lights give a decidedly yellow cast to the result; even using a color-correcting filter cannot be recommended, as the color of the light of such bulbs can vary widely.

Figure 20 **A ring flash unit mounted on the lens of a 35mm SLR camera.**

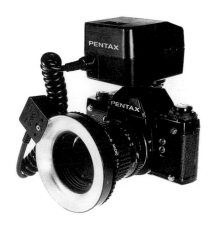

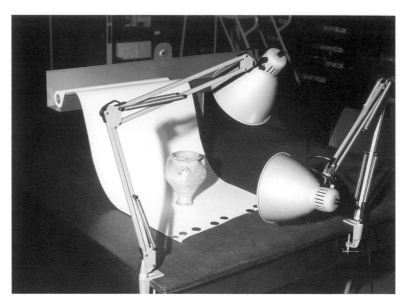

Figure 21 **An object lit by two desk lamps with incandescent bulbs can be supplemented
by, if possible, a third lamp to light the background.**

Another type of electric lighting that is commonly used in both
black-and-white and color photography is tungsten or tungsten-halogen.
Low-wattage tungsten bulbs (up to 200W) are adequate for use with
black-and-white film, but are not suitable for use with color film. Higher-
wattage tungsten bulbs (e.g., 500W) are designed for use with tungsten-
balanced films. However, they also produce a considerable amount of heat,
which means that for many organic materials, such as wood, paper, fab-
rics, and so on, the lights must not be left to shine on the objects for long
periods of time.

The general rule when many types of objects are photographed is
that the main light on an object should come from above, preferably from
the top left. We are all accustomed to seeing the world lit from the sky,
and top-lit objects are therefore the easiest to recognize. With some two-
dimensional or shallow objects, this one key light is sufficient. If the object
is three-dimensional, either a reflector or a fill-in light will be needed on
the opposite side of the object. It may be necessary to use another reflector
or even a third, smaller, light to show a particular detail of the object. It is
useful to devise a few reflectors of different sizes for such purposes. The
cheapest and most effective are pieces of card stock covered with crumpled
and reflattened aluminum foil.

After shape, the second main consideration is texture, the visibil-
ity of which is dependent on the strength and direction of the lighting.

Acutely angled lighting will emphasize texture, and frontal lighting will
flatten it (see figure 22). It is as deceptive to overemphasize texture as it is
to suppress it, although exaggeration of texture might be used in some
instances to increase the visibility of a distinguishing feature. The angle of
lighting must be related to the fineness or coarseness of the surface. For
example, if light is just skimmed across the surface of a flat piece of lime-
stone, it may show the grain of the stone very clearly, but light at a similar
angle across a deeply incised bronze plaque, or a heavily wheel-marked pot,
may give the impression that the plaque is pierced with slits, or the pot
ridged, especially if the light is not balanced with a supplementary source.

The third consideration taken together with texture, is tone and
color. With black-and-white photography, tone—the ranges of grays
between black and white—is all-important. The only reliable way of
ensuring that the range of tones of the print will match those of the origi-
nal object is to include a gray scale (see **Scales and Labels**) in the photo-
graph, making sure that it is lit in the same way as the object. For color
photography, a color reference scale is also needed.

The direction, type, and intensity of light will depend on the size
and type of the object being photographed. Most small objects can be
photographed adequately using oblique lighting—that is, with the main
light falling across the relief of the object, so that the surface is in a rather
darker tone. Cross-lighting of this sort may also produce quite hard shad-
ows, and a reflector may be needed to bounce light back into them. A
reflector of crushed and reflattened aluminum foil, or a low "wall" of foil
curved around the object, can be quite satisfactory (see figure 23). Highly

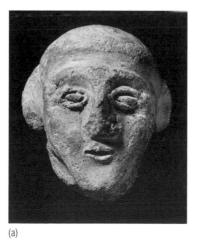

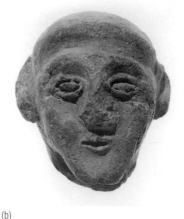

(a) (b)

Figure 22 **Acutely angled lighting emphasizes texture (a), while frontal lighting
flattens it (b).**

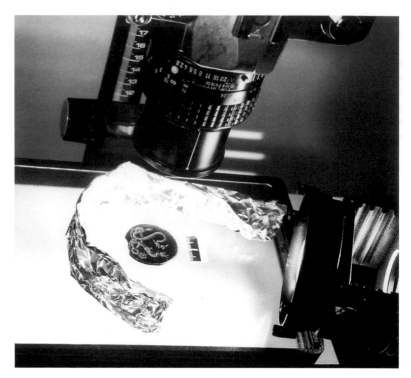

Figure 23 **A reflective low wall of crushed and reflattened aluminum foil used to bounce light into shadows produced by the light source.**

reflective objects such as beads and individual gem stones often respond best to completely diffused light, which can be achieved by surrounding the object with a translucent wall or cone of paper or plastic, then shining the lights onto this surface from the exterior (see figure 24).

When lighting ceramics, the main light should come from the top left, with a fill-in light farther away on the lower right. However, there is a special problem with glazed and burnished wares and porcelain. Lights reflected from the surface may mask the texture, tones, or details of the pot, while if the lighting is so soft and overall that there are no reflections, the vessel may not appear to be glazed or burnished at all. Often the best solution is to use one main light plus a reflector and, looking from the camera position, to move the light about until its reflection falls on an undecorated or unimportant part of the pot's surface.

Light, polished metal, and dark rough metal surfaces require quite different types of lighting from ceramics. Light-colored metal, especially silver, is difficult to light without obtrusive reflections. The best lighting of all is usually diffuse daylight (not direct sunlight), although it may be necessary to position a reflector below and in front of the object to

Figure 24 **Highly reflective objects require diffused light. This can be achieved by surrounding the object with a translucent wall or cone of paper or plastic and then shining the lights onto this surface from the exterior.**

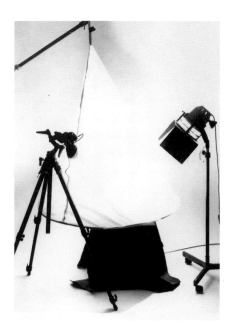

give some light in the shadowed areas. If it is not possible to use daylight, then the lighting should be made as diffuse as possible. The lights can be shined against large reflectors (sheets of paper or foil) instead of on the object, or against walls or ceilings to reflect diffuse light onto the object. When using color film, care must be taken not to reflect light from colored surfaces. Dark, rough metal presents a different problem. If the angle of light reaching the object is too low, surface irregularities might show as hard points of light, and throw shadows on the rest of the body.

Glass objects with simple shapes against illuminated backgrounds often need no other lighting. Cut, etched, or engraved glass, however, will usually need some frontal lighting to show details. This is best achieved either with very soft, overall lighting, or with a single, small light source positioned so that its reflection falls on an unimportant area. As with polished metal, diffused daylight is often the best illumination for glass objects. In photographing furniture, statuary, and sculpture, soft overall lighting is preferable. If the piece is not on or against a white background, it may be necessary to place a reflector below and in front of it to illuminate the shadows slightly. Dramatic cross- or top-lighting should be avoided in record photographs. A single, strong light source can result in confusing shadows beneath or behind the piece. A useful technique when photographing sculpture is to take the picture in a darkened room, using a long exposure and with the illumination provided by a moving light (see figure 25).

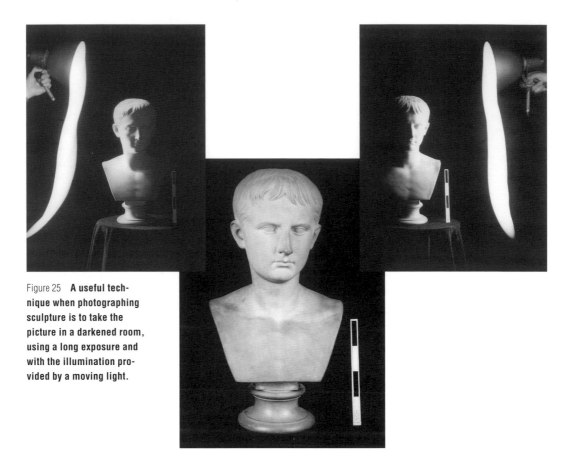

Figure 25 **A useful technique when photographing sculpture is to take the picture in a darkened room, using a long exposure and with the illumination provided by a moving light.**

Some materials are particularly difficult to light. White marble or limestone may appear to lose its texture if the lighting is too frontal, while dark materials like granite or cast bronze may need a great deal of indirect light to reveal their textures. Dark, shiny stone like polished basalt is especially difficult to light, and strong illumination is needed to show the texture of the surface. Overall, very diffused light is usually the best answer and daylight is the best source, if this can be arranged.

A useful technique when photographing sculpture is to make an exposure with a moving light, such as a hand-held lamp, to soften hard shadows and give even illumination. This technique requires a camera on a tripod, a black background for the object, and a dark room. The camera is set for a long exposure (typically, eight seconds at f.22) and the light is moved on either side of the object for approximately four seconds.

Flat objects such as paintings, drawings, and prints require lighting that is as even as possible. This can be achieved by using daylight, although it may be necessary to place a reflector below the original. Two

tungsten lights on stands, set at about 45 degrees to the surface, can evenly cover an area. For large objects, four lights may be needed, one at 45 degrees to each corner, both vertically and horizontally, at a distance of 1 or 2 meters (see figures 26 and 27). The evenness of the lighting can be checked by taking a series of light-readings on a gray card held in the middle and at the four corners of the object.

Lighting canvas and panel paintings for photography is easiest when they are removed from the wall, but if this is impractical, there are options. The first challenge is to achieve even lighting without excessive reflection. With oil paintings with thick brush-strokes (*impasto*), it is often necessary to move the lights from their normal 45-degree position to a shallower or a steeper angle. A polarizing filter may also be useful for cutting glare from the shiny paint layers. Since dark oil paintings, and to a lesser extent, works of tempera can appear muddy and indistinct, it often helps to flood such paintings with light, and to overexpose the photograph. Normally such a procedure would produce a poor result, as the lightest areas would lose detail. But with an uncleaned painting, the lightest tones would themselves be comparatively dark, and there should be little distortion of the tonal range. Such paintings also respond well to infrared photography (see figure 28). For record photography, it is advisable to include the frame in the photograph.

Icons are very similar to oil paintings to photograph, except that they may include areas of precious metals that may cause problematic reflection. If they can be moved, the back should also be recorded, together with any inscriptions. If a number are mounted together, as on an iconostasis, each should be recorded individually and the whole group photographed in order to locate each in its position relative to the whole.

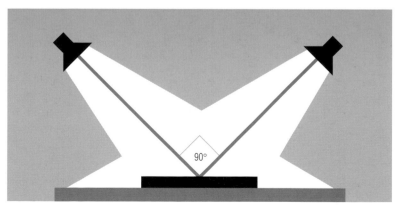

Figure 26 **Two tungsten lights on stands, set at about 45° to the surface, can be used to light flat objects such as paintings, drawings, and prints.**

Figure 27 **For large objects such as a drawing or a painting, four lights may be needed, one at 45° to each corner, both vertically and horizontally, at a distance of 1 or 2 meters.**

Stained glass, wall paintings, and mosaics normally must be recorded in place. When recording mosaics, do not wet the tesserae before photographing the panel or pavement. This can be damaging to the surface and/or the bedding materials, and can also cause unwanted reflections. Lighting can be slightly directional to show the roughness or smoothness of the surface; if the mosaic is of the type with the tesserae slightly tilted in order to catch the light from one direction, the main lighting should come from this direction. A small, fill-in, flash unit can sometimes be used to reinforce the directional light. Mosaic or tiled pavements are often difficult to photograph because of their size and position. Unless the photographer has access to a gantry or the interior of the roof of the building, it is difficult to obtain a square-on view. All that can be done is to achieve as high a viewpoint as possible and to make sure that the image is quite sharp, front to back.

(a)

(b)

Figure 28 **Dark oil paintings, difficult to photograph with black-and-white film (a), often respond well to infrared film (b).**

When lighting carved, flat-faced objects, such as tablets and detached inscriptions, the main light should always come from the top or the top left—never from beneath—and the angle of the light must be adapted to the material. Either flash or tungsten lighting can be used, but the light source should be sufficiently far away that there is no appreciable fall-off of light across the surface. With tablets or deeply cut inscriptions, a reflector should be positioned opposite the main light, otherwise details may be lost in shadow. In the case of small, flat-faced objects with incised or raised detail, small differences to the direction of the lighting can have dramatically different effects (see figure 29).

For fabric and basketry, even, overall lighting is all that is normally needed. This can be achieved by using daylight, or by using four tungsten lamps arranged well away from the object. For detailed work, quite strong cross-lighting may be necessary, and it can be productive to

determine the best arrangement by moving the light around the object while watching the effect. Often, such things as secondary textures and folds in the material will be shown up in this way.

(a)

(b)

(c)

(d)

Figure 29 **Small differences in the direction of the lighting can have dramatically different effects in the case of small, flat-faced objects with incised or raised detail. The object pictured here was photographed with a single light (a); multiple lights (b); flat, reflected light (c); and a ring flash (d).**

Checklist for Photographing Objects

- Select film type appropriate for the task and equipment available.
- Determine what lighting is required.
- Check that the color or tone of the background does not clash with or obscure the object.
- Position the object against the background to show the shape as clearly as possible. Decide whether one viewpoint will be sufficient.
- Check that the texture is clearly shown and that no important parts are in shadow.
- Check that the edges of the object are clear against the background.
- Check that no hard shadows are thrown across the body of the object.
- Place a scale of suitable size, preferably upright, beside the object and about half-way back in its visible depth. Make sure that its shadow is not cast onto the object.
- Place a gray scale, color scale, or information label near, but not touching or overlapping the object. Make sure that its shadow is not cast onto the object.
- Choose the viewpoint that shows the most information and bring the camera on a tripod to this position.
- Make certain that the object is in focus.
- Check that the scale appears upright in the viewfinder and that the information label is clearly visible.
- Take a light reading on the object or on a gray card (not the background).
- Set the aperture as small as possible to give sufficient depth of field, and set the shutter speed to fit that setting.
- Check that the camera and object are perfectly still.
- Expose the film preferably using a cable release.
- If practical, make exposures both one f-stop above and one below the first exposure.
- Record the object and exposure and/or roll numbers in a log book.

Bibliography

Art & Architecture Thesaurus. Los Angeles: Getty Information Institute. The AAT is available, free of charge, on the World Wide Web at www.gii.getty.edu. The AAT is also available through on-line services. In addition, AAT data is available for licensing to organizations developing their own data management systems. For more information contact aat@gii.getty.edu.

Bernasconi, J. R. Inventories and Catalogues for Auctioneers. London: Estates Gazette Ltd., 1976.

Besser, H., and J. Trant. Introduction to Imaging. Santa Monica: Getty Art History Information Program, 1995.

Bostick, W. A. The Guarding of Cultural Property. Paris: UNESCO, 1977.

Brun, R. S. Church Security: A Simple Guide. London: Council for the Care of Churches, 1989.

_____. "The Photography of Church Furnishings for Record and Security." Churchscape, Vol. 9 (1990), 23–37.

Buchanan, T. Photographing Historic Buildings. London: Her Majesty's Stationery Office, 1983.

By-Laws and Code of Ethics. New York: Appraisers Association of America, 1987.

Categories for the Description of Works of Art. Santa Monica: Getty Art History Information Program, 1997.

Chenhall, R. G., and P. Homulos. "Museum Data Standards." Museum, Vol. 314 (1978): 205–12.

Church Protection. Gloucester, U.K.: Ecclesiastical Insurance Group, n.d.

Clément, E., and P. Askerud. Preventing the Illicit Traffic in Cultural Property: A Resource Handbook for the Implementation of the 1970 UNESCO Convention. Paris: UNESCO, 1997.

Collins, S. How to Photograph Works of Art. New York: Amphoto, 1992.

Crago, G., and G. Jeffrey. Safe and Sound?: A Guide to Church Security. London: Council for the Care of Churches, 1996.

Crime Prevention News (London). "The Fine Art of Beating Burglars." July/August/September 1995.

Davison, P. The Camcorder User's Video Handbook. London: Boxtree, 1993.

Dean, J. Architectural Photography. Nashville: American Association for State and Local History, 1981.

Dorrell, P. G. Photography in Archaeology and Conservation. 2 ed. Cambridge: Cambridge University Press, 1994.

Evans, J. Photographic Lighting in Practice. Newton Abbot, U.K.: David and Charles, 1984.

Gerard, R. "Authority Reference Tool Edition for the Art & Architecture Thesaurus: A Review of Version 1.0 and Update." Spectra, Vol. 21, No. 1 (June 1993): 26–27.

Getty Art History Information Program and International Council of Museums International Documentation Committee. Developments in International Museum and Cultural Heritage Information Standards. Santa Monica: Getty Art History Information Program; ICOM International Documentation Committee, 1993.

Grant, A. Spectrum: The U.K. Museum Documentation Standard. Cambridge: Museum Documentation Association, 1994.

Greene, M. "Art Theft Computers." Arts Review, Vol. 42 (April 20, 1990): 213.

A Handbook on the Appraisal of Personal Property. Washington, D.C.: American Society of Appraisers, 1989.

Handbook of Standards, Documenting African Collections. Paris: International Council of Museums, 1996.

Holm, S. Facts and Artifacts: How to Document a Museum Collection. Cambridge: Museum Documentation Association, 1991.

ICONCLASS. The ICONCLASS System and Bibliography, together with a very extensive alphabetical index, were published in seventeen volumes by the Koninklijke Nederlandse Akademie van Wetenschappen (KNAW), in the years between 1973 and 1985. ICONCLASS is also available on the Web at www.iconclass.let.uu.nl.

International Art and Antiques Loss Register Ltd. 1993/1994 Annual Review. London: Art Loss Register, 1994.

Keene, S. "Audits of Care: A Framework for Collections Condition Surveys." In Preprints of the RAI Conference. London: United Kingdom Institute of Conservators, October 1991: 6–16.

Liston, D., ed. Museum Security and Protection: A Handbook for Cultural Heritage Institutions. London: International Council of Museums and Routledge, 1993.

Manual of Guidance on the Completion of the CRIGEN/ART Form. Lyon: INTERPOL Secretariat General, 1996.

Marx, W. P. "Improvement to Risk Management and Security: The Influence of the Insurance Industry." Art Theft and its Control Conference, London, November 1995.

Matters, M. "The Development of Common Descriptive Standards: Lessons From the Archival Community." *Spectra*, Vol. 17, No. 2 (June 1990): 11–13.

Minimum Categories for Museum Objects: Proposed Guidelines for an International Standard. Paris: International Council of Museums, 1994.

One Hundred Missing Objects: Looting in Africa. Paris: International Council of Museums, 1994.

One Hundred Missing Objects: Looting in Angkor. Paris: International Council of Museums, 1993.

A Picture Can Paint a Thousand Words. Produced for the Arts and Antiques Squad of the Metropolitan Police (U.K.) by Hiscox Underwriting, London, n.d.

Porter, V., and R. Thornes. *A Guide to the Description of Architectural Drawings.* Boston: G. K. Hall, 1994.

des Portes, E. "ICOM and the Battle Against Illicit Traffic of Cultural Property." *Museum International.* Vol. 48, No. 3 (1996).

_____. "The Fight against Illicit Traffic in Cultural Property: A Priority for Museum Professionals." In *Illicit Traffic in Cultural Property: Museums against Pillage.* Amsterdam: Royal Tropical Institute and Musée National du Mali, 1995.

Protect Your Art & Antiques. London: Metropolitan Police, 1998.

Protecting Cultural Objects in the Global Information Society (video). Santa Monica: Getty Information Institute, 1996.

Prown, J. "Mind in Matter: An Introduction to Material Culture Theory and Method." In *Interpreting Objects and Collections*, edited by S. M. Pearce. London: Routledge, 1994.

Roberts, [D.] A. "International and National Developments in Museum Information Standards." *Computers and the History of Art*, Vol. 3, No. 1 (1992): 3–6.

Roberts, D. A., ed. *Collections Management for Museums.* Cambridge: Museum Documentation Association, 1988.

_____, ed. *European Museum Documentation Strategies and Standards.* Cambridge: Museum Documentation Association, 1993.

Roberts, D. A., and R. B. Light. "Progress in Documentation." *Journal of Documentation*, Vol. 36, No. 1 (1980).

Rosen, D., and H. Marceau. *A Study in the Use of Photographs in the Identification of Paintings.* New York and London: Garland Publishing, 1975: 75–87.

Schultz, A. W., ed. *Caring for Your Collections.* New York: Harry N. Abrams (for the National Institute for the Conservation of Cultural Property), 1992.

Sorlien, P. C. "Valuation Research and Analysis." In *A Handbook on the Appraisal of Personal Property.* Washington, D.C.: American Society of Appraisers, 1989.

Soucy, C., and J. N. Smyth, eds. *The Appraisal of Personal Property: Principles, Theories, and Practice Methods for the Professional Appraiser.* Washington, D.C.: American Society of Appraisers, 1994.

Thornes, R. *Protecting Cultural Objects through International Documentation Standards: A Preliminary Survey.* Santa Monica: Getty Art History Information Program, 1995.

_____. *Protecting Cultural Objects in the Global Information Society: The Making of Object ID.* Santa Monica: Getty Information Institute, 1997.

Thornes, R,. and J. Bold, eds. *Documenting the Cultural Heritage.* Los Angeles: Getty Information Institute, 1998.

"Tracing Stolen Art." *Museums International*, Vol. 45, No. 1 (1993): 61–63.

Tubb, K., ed. *Antiquities Trade or Betrayed: Legal, Ethical and Conservation Issues.* London: Archetype, 1995.

Turner, J., ed. *Dictionary of Art.* London: Macmillan; New York: Grove, 1996.

Uniform Standards of Professional Practice. Washington, D.C.: Appraisal Foundation, 1997.

Union List of Artist Names. Los Angeles: Getty Information Institute. The ULAN is available, free of charge, on the Web at www.gii.getty.edu. ULAN data is also available for licensing to organizations developing their own data management systems. For more information contact aat@gii.getty.edu.

Wickham, A. "Church Recording." *Surrey Archaeological Collections*, Vol. 80 (1990): 153–59.